ideas for COLLAGE

by Joan B. Priolo

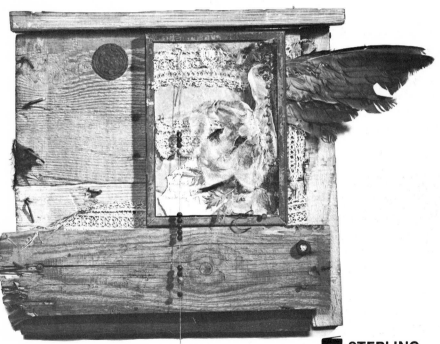

**LITTLE
CRAFT BOOK
SERIES**

**STERLING
PUBLISHING CO., INC.** NEW YORK
SAUNDERS OF TORONTO, Ltd., Don Mills, Canada

Oak Tree Press Co., Ltd.
London & Sydney

Little Craft Book Series

Bargello Stitchery
Beads Plus Macramé
Big-Knot Macramé
Candle-Making
Cellophane Creations
Coloring Papers
Corrugated Carton Crafting
Creating Silver Jewelry with Beads

Creating with Beads
Creating with Burlap
Creating with Flexible Foam
Enamel without Heat
Felt Crafting
Flower Pressing
Ideas for Collage
Lacquer and Crackle

Macramé
Making Paper Flowers
Making Shell Flowers
Masks
Metal and Wire Sculpture
Model Boat Building
Nail Sculpture
Needlepoint Simplified

Off-Loom Weaving
Potato Printing
Puppet-Making
Repoussage
Scissorscraft
Scrimshaw
Sewing without a Pattern
Tole Painting

Whittling and Wood Carving

BY THE SAME AUTHOR

Ceramics—and How to Decorate Them
Designs—and How to Use Them

The author wishes to thank Santa Barbara, California, artists Olga Higgins, Ron Robertson, Katy Meigs, Claire Burgher and Carl Priolo who so generously contributed their time and works to help make this book possible. A special thanks to the author's husband, Tony Priolo, who took the black and white photographs.

Title page collage by Carl Priolo

Contents

Before You Begin 4

Making Paper Collages 6

Colored Tissue-Paper Collages 14

Rice-Paper Collages 18

Newspaper Collages 19

Wallpaper Collages 26

Collage with Books and Magazines 30

Make Your Own Collage Papers 37

Finishing Your Paper Collage 42

Collage with Other Materials 43

Fabrics . . . Assemblage

More Ideas for Collage Elements 47

Index 48

Before You Begin

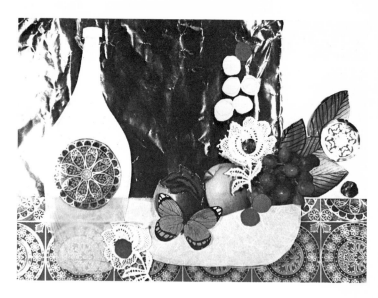

Illus. 1. Gold and patterned gift papers are used in this decorative collage. The bottle and bowl are cut from tracing paper and the fruit is from a magazine illustration. White lace flowers complete the still life.

What is collage? Chances are that you have already made a collage at some time, perhaps without realizing it. If you have ever made a valentine of paper hearts and lace, pasted mementos in a scrapbook, or decorated furniture with flowers cut from magazines, you have made a collage.

There is nothing really new about collage. It is a pasting medium as old as folk art and as modern as the 20th century. It can be as simple as the valentine you made or as complex as the most intricate work of art. In fact, collage can be just about anything you care to make it.

Many famous artists have used collage to make lasting works of art. In the early 1900's, the great artists Pablo Picasso and Georges Braque intro-

duced pasted pieces of wallpaper and oilcloth into their paintings and, from this beginning, collage developed into what is now an art technique as important as painting. However, you do not have to be a Picasso to have fun with collage—but who knows, you may discover that you are more of an artist than you dreamed!

One of the many attractions of collage is the lack of expensive materials involved. Basically, all you need for collage are paste, any object that can be pasted, and an appropriate backing material, which can be anything from a cardboard shirt backing to a lamp shade.

Look around you for your materials. They are everywhere—in your wastebasket, in a used-book shop, and in your storeroom, basement, or attic.

As you look, you will find everyday objects taking on an unsuspected importance. Suddenly, everything becomes a possible collage element. The Christmas wrapping paper you might have thrown away, an old piece of lace from your grandmother's trunk, old shoelaces, the ticket stubs from last night's movie, an outdated calendar—all can be used in a new way.

You can make your own collage materials or use the discarded fragments of your world to create a collage of purely abstract beauty, a collage that tells a story, or, with your own photos, a bit of personal history. With cutouts from newspapers you can recreate a chapter of world history.

With old letters, scraps of ribbon and old lace, you can evoke a mood of Victorian nostalgia. You can "paint" a still-life collage, a landscape, or a modern geometric design with paper or fabrics.

The choices are endless and your creations will be unique just as you are unique. That is what makes collage the personal and expressive medium that it is.

In this book you will learn some of the many ways to make a collage, with the hope that these ideas will inspire you to experiment and discover all of the exciting things that collage can be to you.

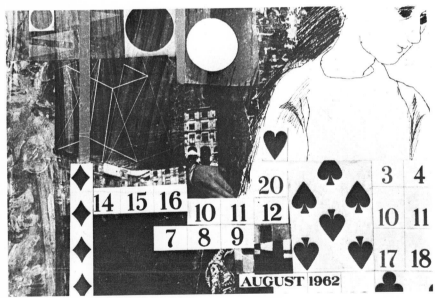

Illus. 2. "Moment of Truth" by Olga Higgins. An outdated calendar, playing cards and a line drawing are interesting elements in this collage.

Making Paper Collages

Paper is the classic collage material and, possibly, the one you will use most often. There are so many papers available to the collagist, ranging from discarded grocery bags to elegant Japanese rice papers, that it is sometimes a dizzying prospect to make a selection.

Now, before going into the selection of papers, other materials, methods and techniques, let's make a simple paper collage as an experiment.

The only problems you may ever have in making a collage are how to start and when to stop.

The first thing to consider when starting is size. Since this is your first collage, it is best to start small—probably no larger than $9'' \times 12''$—until you become more familiar with the technique.

Next, choose a backing. There are many suitable backings on which to paste your collage. Almost any fairly stiff cardboard will do. You can use the cardboard backs of drawing pads, illustration boards, matte boards, cardboard shirt backings, canvas boards, even stretched canvasses (although there is not much point in going to the expense involved unless you plan to use collage in combination with painting).

One of the most satisfactory backings is a smooth, brown pressed board, called Masonite commercially. It is heavy enough to prevent

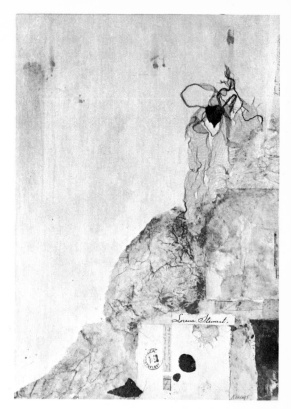

Illus. 3. "Misery, Charlie C." by Katy Meigs. In this delicate collage, an old letter, sealing wax and a piece of tulle are combined with hand-colored tissue paper and water-color paper.

buckling which sometimes occurs with lighter-weight boards. Masonite is available at some art supply shops and at all lumberyards. It is cheaper, if you plan to do a number of collages, to go to a lumberyard and have a $\frac{1}{8}''$-thick Masonite board

(which comes in a 8′ × 4′ size) cut for you to your specified sizes.

If you want a white background, which is only necessary if you are using transparent paper or plan to leave white areas showing, you can brush several coats of white vinyl house paint on the front of the board.

Gesso boards, which are Masonite boards already prepared with a white gesso ground, are also available at art supply shops.

(In addition to cardboard and Masonite, after you have made a few experimental collages, try lamp shades, boxes, furniture—even walls—for your collages.)

Then choose your basic background paper—newspaper, wallpaper, tissue paper, gift paper,

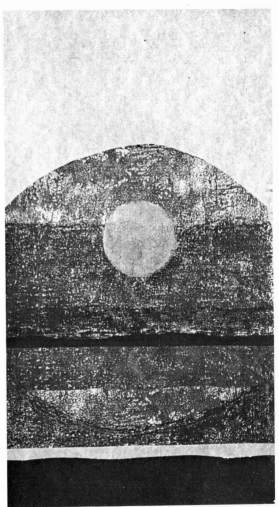

Illus. 4. A white illustration board is the backing for this simple collage of torn, mottled (see page 40) paper shapes. Small pieces of wallpaper cutouts provide interesting details.

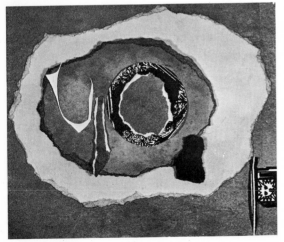

Illus. 5. Areas cut from silk-screen prints create a collage of serenity.

Illus. 6. A background of mottled paper is divided into two areas by a torn paper of darker color, suggesting a landscape. Notice the white linear edge made by tearing the paper after it was colored.

rice paper, etc. You can now start experimenting, without pasting down, by working with cut or torn pieces of construction paper* which will approximate the size, shape and color of your final elements. You need not select the final paper materials until you are satisfied with the arrangement. The pieces of construction paper will undoubtedly suggest many items when you see them in place—flowers, bottle labels, letters, photos—anything that comes into your mind.

Construction paper is inexpensive and easily available in art supply and variety shops, and will save you much time in the experimental stage.

———————————

*Cut or torn pieces of colored tissue paper may be used as well as construction paper.

It is not a good idea to use construction paper in a final collage because of the fading-color problem. However, there is a brand of paper very similar to construction paper which is nonfading and which is found in art supply shops. On the other hand, you may find faded construction paper to your liking, so try it anyway.

A word here about tearing, since you will be doing a lot of it. Depending upon the kind of paper that you choose to work with, you will find that the paper tears more easily in one direction. All paper—even cellophane—has a grain just as does wood. If you look at a tabletop you will see definite lines, which are the fibrous structure of the wood. They run in only one direction.

In most papers it is very difficult to detect the

Illus. 7. Torn pieces of maps are pasted on the background, carrying out the landscape idea in a semi-abstract manner.

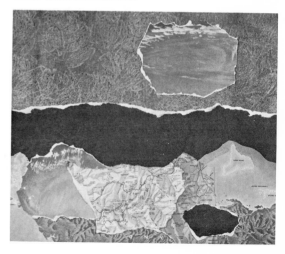

grain by eye, so you should practice on various papers to determine which way the grain runs. Take a sheet of newspaper and try tearing it, first up and down, and then across. You will find one direction tears in a straight line—this is the direction of the grain. Tear in the other direction and you find the paper tears any which way.

On many occasions, you will find torn papers produce more exciting results than cut papers. After practicing, you will also discover you can control the tearing process to create the kinds of shapes you want. Experimental tearing against the grain might result in fascinating forms you could never achieve by careful planning and cutting.

Unless you have a clear idea in mind, it some-

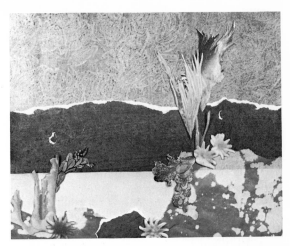

Illus. 9. A fairly realistic collage is created by adding cutouts of sea vegetation from a nature book and pieces of bleach-spotted tissue paper.

Illus. 8. The addition of a cut strip of light-colored paper to the divided background of Illus. 6 suggests an underwater scene.

times helps to get started by dividing your selected background into two or more areas. Try placing a torn or cut paper over one third of the background, either vertically or horizontally (Illus. 6). This will give you the beginning of a structure on which to build and may suggest a landscape or other images to you.

Now, using your pieces of construction paper which you can either tear at random before you begin or as you go along, start shifting them around on the background paper. Do not use too many elements at the start—you will just get confused and end up trying to get them *all* into the collage when they might not belong there at all.

9

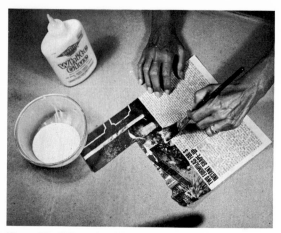

Illus. 10. Diluted white glue is brushed on the back of a photograph of roses, cut from a magazine.

Keep it simple. Shift and shuffle until you are satisfied.

From here on, it is simply a matter of building by addition and subtraction. Don't overlook subtraction! It is an important factor in the making of a collage. The tendency may be, when the collage is not shaping up, to add too many elements in the optimistic belief that more is better. This often builds disaster upon disaster and hides what may be a basic defect in structure or color. Learn to be a little ruthless. Take away shapes and colors that aren't working and try something different. Since you don't have to paste anything down until you are satisfied, you are free to try anything.

While in the process of shifting papers around,

try placing your collage on the floor. In this way, you can stand back and get a proper perspective. Working too close to the collage can give you a distorted view and you may tend to concentrate on the parts, rather than the whole.

Sometimes, you may find that when placing and shifting the papers, they do not lie flat and cause shadows and other distractions. A few straight pins or coins will temporarily hold down unruly edges so you can see what you are doing.

Once you are happy with the composition, make a rough cartoon of it. Number your pieces of construction paper and place corresponding numbers on your cartoon. Assemble your final paper elements and you can paste if you want.

The most popular pasting medium is white glue, or casein glue, commercially called Elmer's glue. White glue is available at variety and art supply shops, and hardware stores. It will paste down plastic, paper, board, foil—almost anything.

When pasting paper, white glue should be diluted with water to the consistency of milk. If it is too thick, it tends to dry too fast and make positioning your paper difficult. Simply brush the diluted glue (using an inexpensive brush) on the back of the paper to be pasted down and also on the surface to which the paper is to be pasted.

When you have positioned your paper, smooth it with your hands from top to bottom and side to side to eliminate air bubbles and prevent wrinkling. Often, when using very large pieces of paper, some wrinkling is unavoidable. If this occurs, you can weight your collage when it is finished. In most cases, this will flatten out any wrinkles or air bubbles.

However, if you are planning to paste addi-

tional paper over the wrinkled paper, it is a good idea to weight the wrinkled areas of the collage for between half an hour and an hour before proceeding with more pasting. If you choose to weight as you go along, simply leave the collage face up, place waxed paper over the surface and then place cardboard, with weights, on top. *Don't forget the waxed paper* because, at this stage, there is the chance that there are some spots of still-tacky glue that will need the protection of waxed paper. You could wind up with an unexpected and permanent addition to your collage —a second cardboard!

Glue that comes in a spray can is more expensive than white glue, but is more convenient for a number of reasons. It is less messy and cuts pasting time in half because you need to spray only one surface with glue. It also has the advantage of eliminating most wrinkle problems, even with large pieces of paper.

To help prevent buckling of the lighter-weight background boards, especially when using diluted white glue, saturate the back of the board with water before you start pasting. This will help to stabilize the stress on the board. This step is seldom necessary when using spray-can glue because this glue does not soak the board enough to cause much stress.

Another type of glue often used in collage work is an acrylic painting medium which is used primarily to thin acrylic paints. However, it makes a satisfactory glue and is used in the same manner as white glue. The advantage of this glue is that, as you paste, you can brush the glue over the surface of the papers and in this way build up layers of a waxy varnish, giving depth and protection to your finished collage. This is available at all art supply shops.

While in most cases (except when working with tissue paper) you will probably not paste the collage down until the final stage in planning, there are times when it is beneficial to work quickly and paste as you go. It is a good way to force decisions when artistic paralysis has set in. This condition is caused by too much indecisive staring. When this happens, pasting something down sometimes gets you and the collage moving again. Although you can't remove the pasted paper, you can usually paste other papers on top to block out unsuccessful areas.

Throw away your experimental collage if you don't like it. You have at least learned the process.

Collage is a flexible craft, and very few deci-

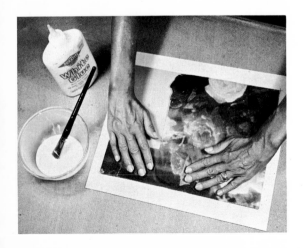

Illus. 11. The paper is pasted down and smoothed with both hands from side to side to prevent wrinkling.

sions are irrevocable. There is almost always something that can be done to rescue a collage. However, don't spend too much time on a collage that doesn't seem to be working. If, after a reasonable length of time, things are looking somewhat discouraging, leave the collage and start another. Better still, try working on two collages at the same time. Many artists work this way and find that it keeps ideas flowing and lessens the danger of "paralysis."

When is a collage completed? Only you will know when to stop. You may experience the feeling of elation that comes when everything seems to fall magically into place and you know you have finished a good piece of work. However, you may reach a point just short of completion where something seems amiss, but you don't know why or what to do about it. If you aren't sure what is needed, put the collage away. A few days' time will give you a new perspective and you may be able to spot just what is needed to bring the collage to completion, or you may even decide to give up the whole thing. In any case, give yourself and the collage a trial separation before you decide.

Your attitude will have a great deal to do with the success of your collage. A *"Well, it's only paper"* approach will enable you to experiment with greater ease than a *"This has to be a masterpiece"* approach which will only make you afraid of failures—and, believe it or not, failures are necessary. Learn to respect them. They will teach you as much as successes. Free yourself of too many preconceived ideas and take advantage of the things that happen while creating. This is, after all, what it is all about.

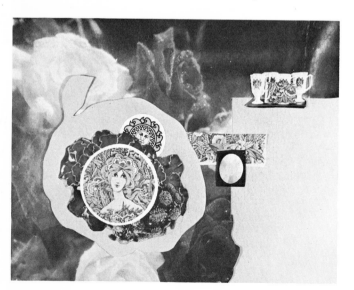

Illus. 12. Other pieces of paper, cut from magazines, are pasted over the background of roses to complete the collage.

Illus. 13. "Jade on Red" by Joan Priolo. Cut papers, mottled with acrylic color, are combined with large areas of flat, colored paper to make this hard-edge collage.

13

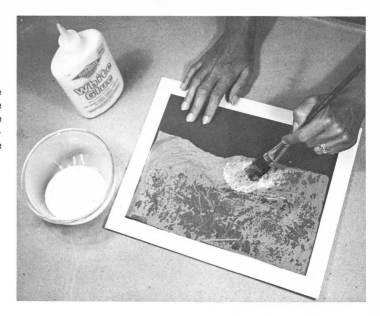

Illus. 14. Pasting colored tissue paper on a black background. The diluted glue is brushed over the surface of the tissue paper, adhering it immediately. Notice the resulting texture.

Colored Tissue-Paper Collages

One of the most widely used papers for collage is colored tissue paper. This paper is available at art supply and hobby shops and comes in sheets of every imaginable color. It cheers up a gloomy day just to stand in front of the display rack and look at the colors.

Since tissue paper is transparent, you can, in a sense, "paint" with it by pasting one colored paper over another. The paper is so thin that, when you paste, you need only place the paper in position and brush diluted white glue over the surface. The glue will soak through the paper immediately to the surface of the backing, pasting the paper in place.

This is one of the papers it is most fun to work with because you can work so quickly, tearing or

cutting shapes from the paper, positioning them and then slapping glue over the surface. You can build up as many layers as needed.

The bleeding of the colors creates unusual and, often, unexpected effects, so that you are always a little surprised at what is happening. Here, too, is an instance when wrinkles can work for you. If you crumple the paper, then place it and paste, the bleeding colors will transform the wrinkles into delicate traceries.

Planning ahead with tissue papers is almost impossible since the papers change when pasted, making decisions dependent on the happenings of each pasted paper. This necessity to paste as you go helps to keep ideas flexible and is of special benefit to anyone starting in collage and to everyone when "loosening up" is in order.

A word of caution, however, about the permanence of the colors. Because the colors *are* so fugitive, they tend to fade after exposure to light for any length of time. For greater permanence you can tint the tissue paper with water colors or acrylic colors before or after pasting. (See color Illus. 16 and Illus. 19 on pages 16 and 17.)

Illus. 15. Many layers of tissue paper were used to "paint" this collage of colored tissue papers.

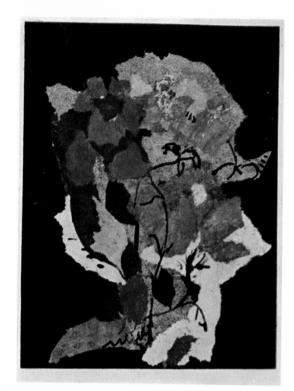

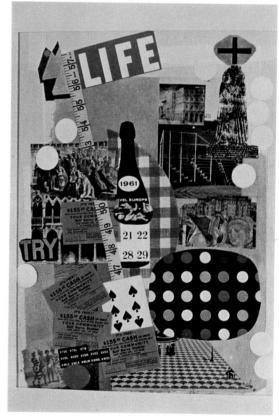

Illus. 16. Collage by Claire Burgher. Tissue papers tinted with water colors are used to make this collage. A few black pen lines add interest.

Illus. 17. "Life" by Olga Higgins. Raffle tickets, a tape measure, magazine cutouts, playing cards and calendar numbers are pasted on a rice-paper background to make this stunning collage.

16

Illus. 18. "To the City" by Joan Priolo. Courtesy of Mr. and Mrs. George Brooks. Torn pieces of colored rice paper and small cutouts from magazines evoke a faraway city. The background is pasted paper washed with acrylic color.

Illus. 19. "Going Home" by Katy Meigs. A piece of sheet music adds interest to this collage of tinted tissue papers and watercolor papers.

Rice-Paper Collages

Another popular paper for collage is Japanese rice paper. Most art supply shops carry a wide selection of rice paper, ranging from soft, white, translucent paper, often with grass and butterfly patterns, to colored opaque paper and oatmeal paper shot through with darker cloth fibres.

Rice paper has several things going for it. For one thing, the colors of the opaque papers do not appear to fade very much. Another beneficial characteristic of rice paper is that it lends itself beautifully to tearing, resulting in collage shapes with soft, cloudy edges. Also, while tissue paper is available only in solid colors so that any irre-gularities must be made by the collagist, rice paper is available in many interesting textures.

Most rice paper is thin enough to paste in the same manner as tissue paper.

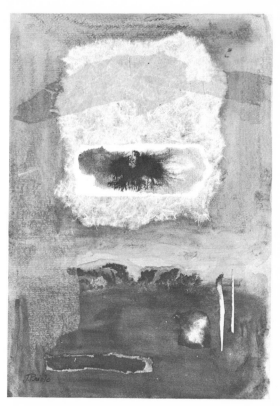

Illus. 20. Japanese oatmeal rice paper and colored tissue paper are combined with acrylic paints in this collage-painting on canvas.

Illus. 21. A large, torn shape of translucent, white rice paper is the focal point in this collage. Small hand-colored pieces of paper are added and all are pasted on pastel paper treated with a wash of color.

Newspaper Collages

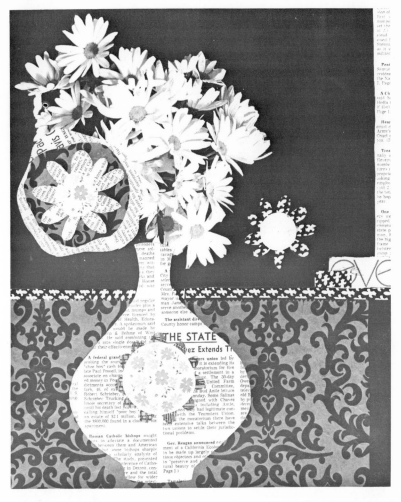

Illus. 22. This collage (See Illus. 26-Illus. 29) shows the final addition of a center, cut from newspaper and gift paper, in the large flower shape and a gift-paper circle on the vase. The small flower shape and rectangle on the side were cut from a newspaper advertisement.

The one type of paper that almost everyone has access to is the daily newspaper. From the large, black headline lettering to the colored pages of the Sunday supplement, you will find a wealth of material for collage.

You can cut or tear shapes of newspaper and use them as you would any patterned paper or you can collage today's headlines into a historic document. Newspapers yellowed with age will impart a nostalgic mood to your collages.

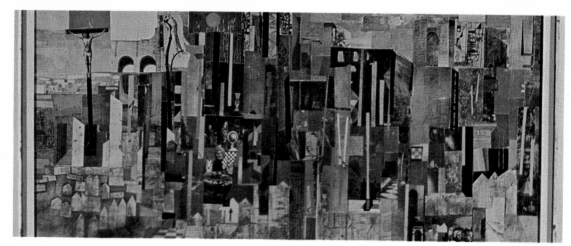

Illus. 23. "Eternal City" by Olga Higgins. An intricate collage on plywood, combining magazine cutouts and pieces of cardboard on which lines are incised with a tracing wheel.

Illus. 24. "Youth Rally" by Olga Higgins. The textured side of a Masonite board, painted with casein, is the background for this exuberant collage of magazine cutouts.

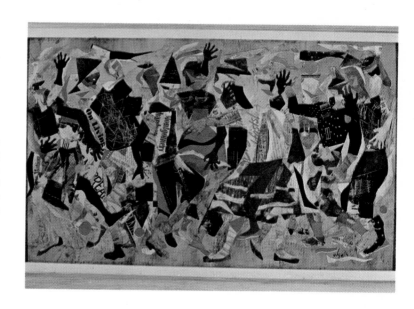

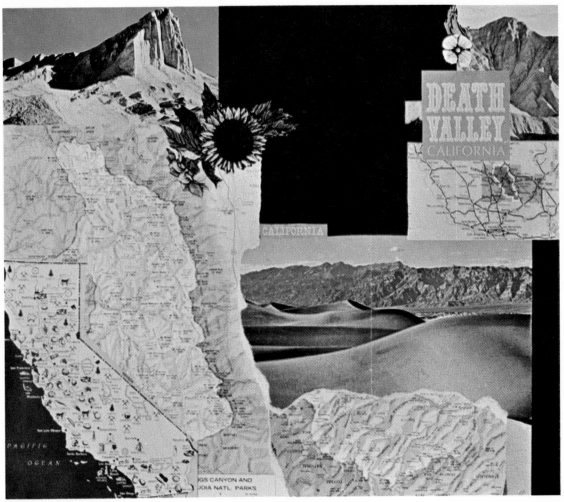

Illus. 25. "Death Valley" by Joan Priolo. A vacation memory is preserved in this collage with a postcard, maps, and cutouts from a Death Valley, California vacation brochure.

Illus. 26. A wide strip of black-and-red patterned gift paper is pasted on a black background.

If you should be in an area where you have access to Japanese or Chinese newspapers, you will find the Oriental characters an intriguing asset to your collage. By combining pieces of Oriental newspaper with Japanese rice paper or by veiling the newspaper with colored tissue paper, you can evoke the mystery of the Orient. This is what is so fascinating about collage. By your choice of materials alone you can determine the mood of a collage.

Illus. 27. Horizontal and vertical strips of newspaper are added.

Illus. 28. White and yellow daisies, cut from the colored supplement of a Sunday newspaper, are pasted on the black upper part of the collage.

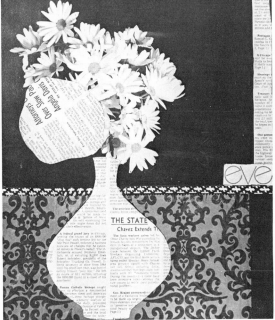

Illus. 29. A vase and a large, roundish flower shape, cut from newspaper, are added.

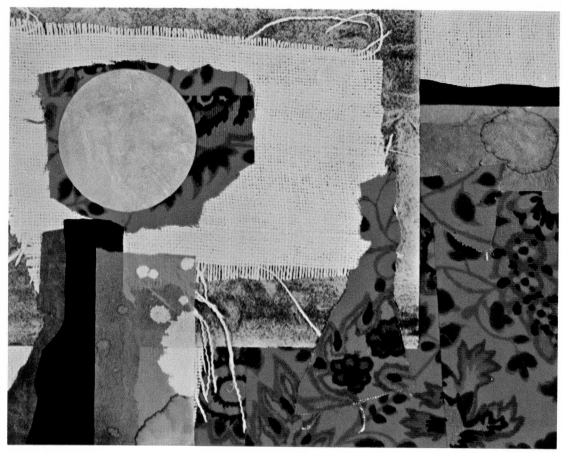

Illus. 30. Collage by Joan Priolo. Burlap and flowered fabric are combined with colored tissue paper and hand-colored papers to create this colorful collage.

Illus. 31. Collage by Carl Priolo. A colorful collage made with cutouts of nonfading construction paper.

Illus. 32. "Kennst Du Das Land?" by Katy Meigs. A delightfully gay collage of newspaper shapes integrated with areas of oil pastel and water color.

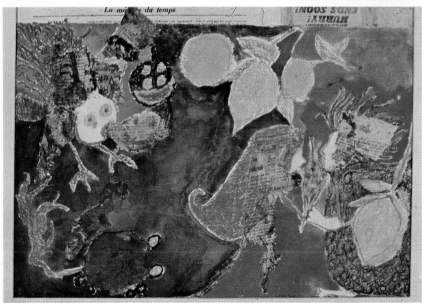

Wallpaper Collages

Illus. 33. Bold, decorative shapes cut from black and white wallpaper make an interesting contrast to patterned gift paper and black paper in this collage.

Wallpaper is one of the most decorative of collage papers. For this reason, it should be used with some restraint or your creation may end up looking like an attractive wall! Generally, it is a good idea to use wallpaper in combination with other papers. Areas of colored tissue paper, bottle labels, hand-colored papers or newspaper can help keep the wallpaper under control.

Collages with a Victorian aura can be made by combining old-fashioned flowered wallpaper with paper lace, old photos and bits of ribbon. Textured wallpaper can add areas of interest, while bolder elements can be cut out from modern wallpaper for striking contrasts.

However, there are no hard-and-fast rules in collage and it could be a real challenge to make a collage entirely from wallpaper. Moreover, it is a good visual exercise to see how well you can arrange decorative, patterned papers into a unified collage.

When pasting wallpaper, white glue is good, but, with some of the heavier papers, you may find the spray-can glue more satisfactory.

You should have no difficulty in obtaining, free of charge, enough wallpaper to paper a house if you go to your local wallpaper store and ask for leftovers. In most cases the store will be happy to get rid of remnants or discontinued pieces and rolls of wallpaper.

Illus. 34. Pieces are cut from various patterned wallpapers.

Illus. 35. Here is how the above materials might be arranged to create a wallpaper collage of patterned papers.

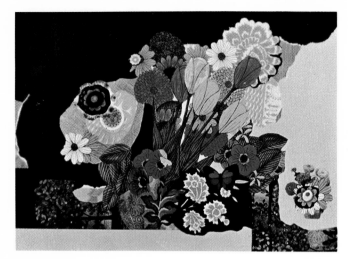

Illus. 36. Collage by Joan Priolo. A collage of contrasts is created with flowers cut from gift paper, flat areas of black and bright yellow paper and a few fabric flowers.

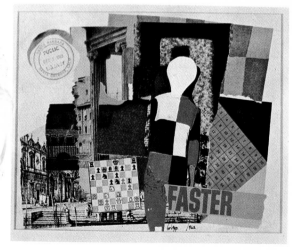

Illus. 37. "Faster" by Olga Higgins. Magazine cutouts and a postmark combine to make this striking collage. The background is rice paper on chip board.

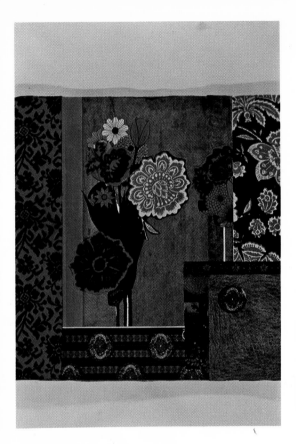

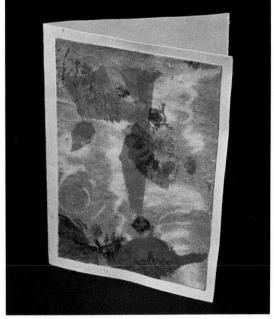

Illus. 38. Collage by Joan Priolo. Fabric cutouts add depth to this collage of magazine cutouts and hand-colored papers.

Illus. 39. Greeting card by Claire Burgher. A charming greeting card of colored tissue paper. The light areas are made by brushing on a design of liquid bleach.

29

Collage with
Books and Magazines

The literary world is one of the richest sources of collage material. Browse around in used-book shops whenever you have a chance. You will come across wonderful old prints of birds, mechanical diagrams, old books with odd, old-fashioned illustrations and, often, beautiful lettering. Nature books and old encyclopedias are full

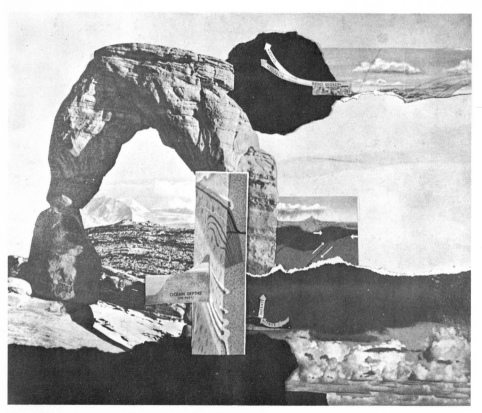

Illus. 40. A scenic collage is made with photos and diagrams from a geographic magazine.

Illus. 41. Lettering is cut out from an art magazine to be used in the collage shown here.

Illus. 42. The lettering and a large piece of black paper are arranged and pasted on a background of creased paper (see page 40). In this collage, the lettering is used in an abstract manner as design.

of drawings and photos of birds, fish, shells, plants and flowers. You will also find many, many, old, fully illustrated children's books. If you are very lucky, you may come across old sheet music—both the covers and the music itself would make rare additions to a collage. Thrift shops and junk shops are other treasure troves of old paper materials.

If you have a worn-out atlas, look at the maps with their complex traceries. Historical maps are particularly interesting with their colored-in areas. You might also save your old road maps and combine them with pictures from travel brochures to create a collage of vacation memories. (See Illus. 25.)

Scientific magazines hold a world of surprises. Intricate diagrams, graphs, arrows and precise

Illus. 43. The top of this jewelry box "for Ann" is collaged with a background of crumpled gold paper over which are pasted gift paper cutouts and a large letter A.

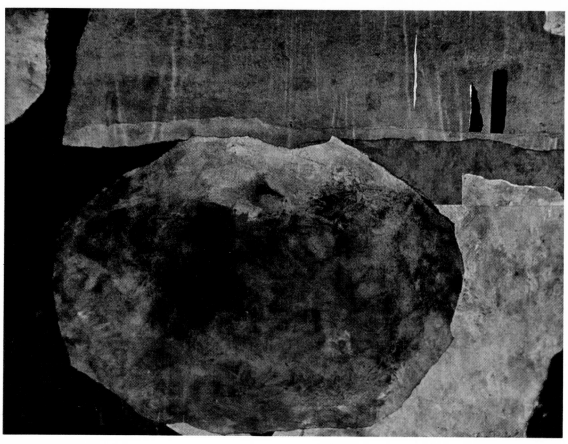

Illus. 44. "Contemplation" by Joan Priolo. This collage is "painted" with torn shapes of mottled paper. Notice the darker, linear edges of the shapes. These are caused by tearing the paper shapes before coloring (see page 40).

Illus. 46. "Samurai Gone" by Ron Robertson. This bold collage is composed of various Japanese wrapping papers, oil paint and calligraphic strips of modelling paste.

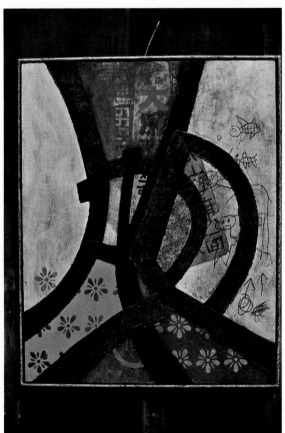

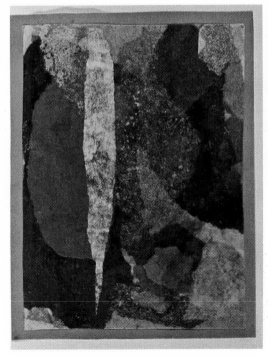

Illus. 45. Collage by Claire Burgher. Colored tissue papers create the soft, autumn colors of this collage.

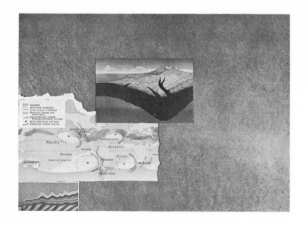

drawings can be used to make collages of pristine elegance.

The contemporary slick magazines with their sophisticated illustrations and advertisements contain endless collage elements. Here you will also find interesting lettering. Letters can be as effective as abstract patterns or as words to convey a message.

Don't forget seed catalogues as a source of

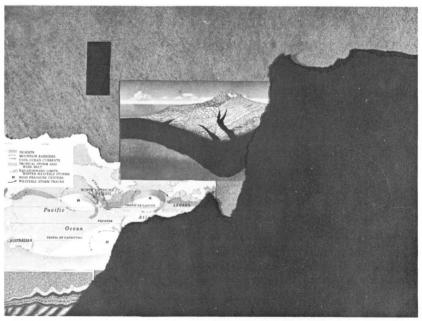

Illus. 48. A large mountain shape of torn, black paper and a small black rectangle are added.

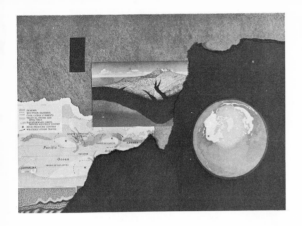

flower photos, as well as mail-order house catalogues, which are also very colorful.

Start collecting now so that you will have a stockpile of material for that rainy day that comes now and then when you haven't an idea in your head. You will be surprised at the flow of ideas that can start just from sorting through a pile of collected odds and ends.

Illus. 50. The finished collage shows the addition of two more diagrams and a torn, circular shape. Notice the arrows—they are interesting details.

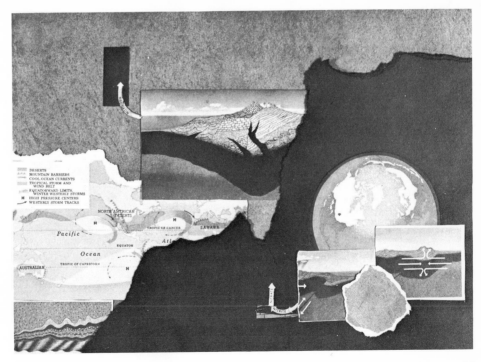

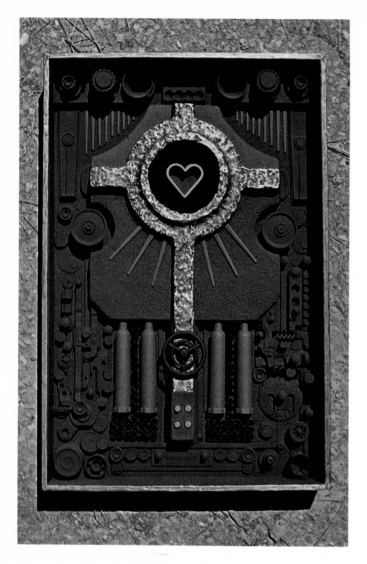

Illus. 51. "Shrine Series" by Ron Robertson. A variety of everyday objects is transformed into this elegant assemblage. Silk-screen paint is sprayed over such articles as marking pens, Bingo chips, a battery control, cigarette filters, and buttons. The heart shape is a plastic cookie-cutter, and the silvery material is Sculp-Metal.

Make Your Own

Collage Papers

Once you have worked with a variety of ready-made papers, you will, on occasion, want to obtain special effects by making your own collage papers.

Colored tissue paper, because of its bleeding properties, lends itself perfectly to special effects. One way to obtain an interesting result is to drop water with an eyedropper or brush on the tissue paper. The water will take off some of the color,

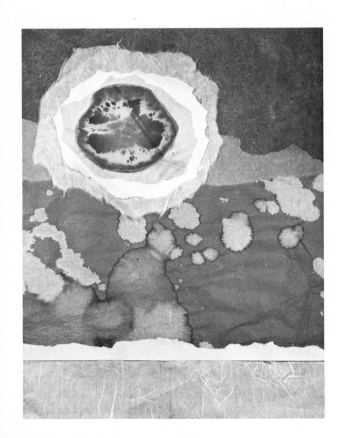

Illus. 52. This ethereal collage is made with water-spotted blue tissue paper. The roundish shape at the top is torn from translucent, white rice paper with an inner circle of white pastel paper and an accidentally stained piece of blue tissue paper. The bottom strips are torn from rice paper and pastel paper.

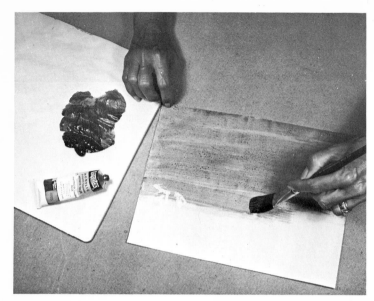

Illus. 53. The first step in mottling paper is to brush on a wash of color. Acrylic color is used here.

Illus. 54. After the color has dried for a few seconds, gently blot it with a facial tissue to produce the mottled effect.

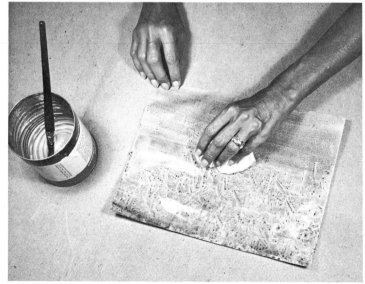

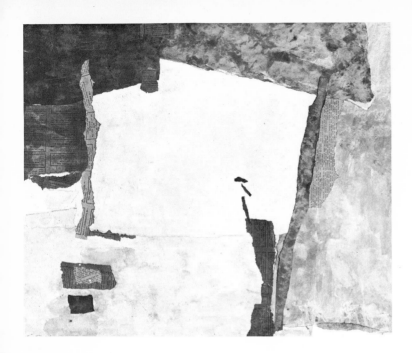

leaving soft areas of lighter color. If you substitute liquid bleach for water, the areas will be white. You can leave the bleached areas white or tint them with water colors or acrylic colors.

Almost any white paper can be used for coloring purposes: drawing paper, charcoal paper, water-color paper. It depends on the weight you require. For small areas, lightweight paper is satisfactory, but for very large areas, it is best to use heavier paper. Large pieces of thin, lightweight paper are difficult to paste down. They tend to exhibit a contrariness of spirit and flap about doing their own thing. Tissue paper is an exception since you can anchor it immediately by brushing white glue directly onto the surface.

To color your collage papers you can use water colors, acrylic colors, oil pastels, wax crayons, and even tea, coffee, frozen orange juice concentrate, or grape juice.

Probably one of the simplest coloring methods, and one that works well for backgrounds, is to give your paper a wash of color. Wet the paper thoroughly with a sponge or brush. While the paper is still wet, load a brush with water color or acrylic color and paint into the wet paper. If your paper is well saturated with water, the paint

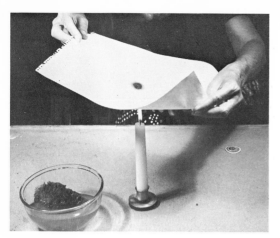

Illus. 56. After a piece of paper has been saturated with water, it is held over a candle flame in a cleared area to make smoked and burned areas.

and you should have a luminous violet color. To darken or tone down a color, use black as the first color, blot it, let it dry and wash a clear color over it. Do some experimenting with this technique. By combining color with color or black with color you will discover a new range of colors. It is possible to "paint" a collage by using mottled papers without other collage elements. (See Illus. 15.)

Torn edges give still another dimension to this technique because, by tearing the paper before mottling, the color sinks into the torn edge and gives an almost linear dark edge to the shape. If you tear the paper after coloring, you will have a white linear edge. (See Illus. 6.)

Another way to texture paper is to crumple a piece of white paper, smooth it out and wash a color over it. The color will sink into the creases, leaving a pattern of fine lines. For a softer texture, saturate the paper with water before coloring.

Keep your eyes open for paper that has been accidentally textured or colored. Take a second look at the paper with a coffee or tea stain on it. (Most of us have a good supply of these papers.) A used sheet from a paper palette often has fascinating areas of dried color that can be incorporated into a collage. A piece of black tissue paper that landed, wet, on blue tissue paper can leave a stain to delight the heart of any collagist.

Wax crayons or oil pastels can give your paper a patchy, crosshatched texture. It is best to use at least two colors with this method. Scribble over the entire paper with one color. Then scribble in the opposite direction with a second color. Since some of the paper will show through, try scribbl-

will spread into uneven, feathered areas. Be sure to put enough color on your brush since the water will dissipate the color somewhat. This is as effective as a background for further collage or as a means of coloring small pieces of paper. Colored pastel or charcoal paper makes a good background when treated with a wash of a contrasting color.

For a mottled paper, paint the entire paper surface with a color, let it dry a few seconds, and then blot the paper gently and evenly with a facial tissue. You can take this a step further and use two colors to obtain a luminous effect. For example, if a violet color is desired, mottle the paper with a blue color. When the mottled blue has completely dried, go over it with a wash of crimson

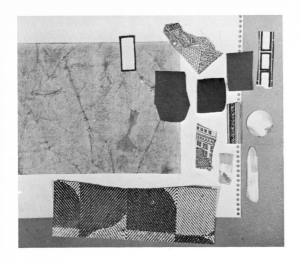

ing on colored construction or pastel paper for a three-color effect.

You can make interesting collage paper by smoking or burning the paper. Saturate the paper with water and pass it over a candle flame, but not too close. This will create smoked areas, or, if you hold the paper closer to the flame, burned holes. Be sure to do this in or near a sink or you may create some startling and undesired effects!

Illus. 58. The materials are arranged and pasted on a background of creased paper to create this "cityscape."

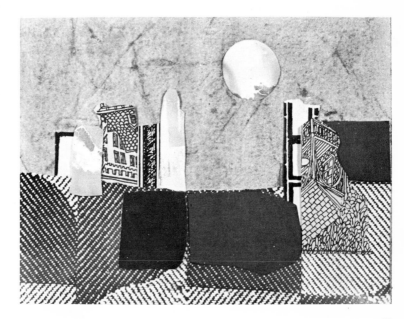

Finishing Your
Paper Collage

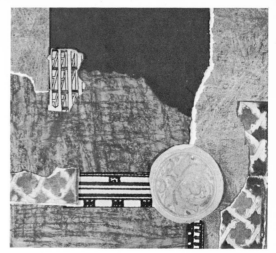

Illus. 59. Cut and torn pieces of gift paper and black paper are pasted on a background of colored pastel paper crosshatched with oil pastel.

If, when you have finished your paper collage, you find that it has buckled, as is sometimes the case with lightweight backings, don't be discouraged—you can weight it.

Place the completed collage face down on clean newspaper, making sure that the glue is dry. As an added precaution against sticking, place waxed paper between the surface of the collage and the newspapers. Then place more newspapers on the back of the collage. Wet the newspapers with water, using a sponge or brush. On top of the wet newspapers place a piece of cardboard, Masonite or even an unsuccessful collage (it does happen) the same size or larger than your collage. Then pile anything heavy, such as large books, on top of the board. Leave the weighted collage at least overnight. By morning you should have a nice, flat collage. The weighting should also take care of any wrinkles or air bubbles that might have occurred while pasting.

You undoubtedly will want a protective finish for your collage. Glass is, of course, an obvious solution. If the collage is fairly small it can be glassed with no problem. With very large collages (30" or more), some expense is involved along with a weight problem. In these cases, try some of the acrylic varnishes available at your art shop. They are easy to brush on and will give your collage a glossy or matte finish. If you have used an acrylic painting medium as your glue, you probably have built up enough layers of a protective varnish already. There are also lacquer sprays available that will protect your collage.

Every kind of paper, as you will find out for yourself by trial-and-error, must be handled according to its own characteristics. For instance, yellowing of paper is caused by acid in the fibres. Some papers are more highly acid and will yellow more quickly than others. Some papers are affected by skin oil and will eventually discolor where overhandled. Take care of your paper productions by avoiding overexposure to heat, moisture or sunlight.

Collage with Other Materials

Fabrics

You will find cloth fabrics a fascinating source of color and texture for collage. Cloth has a distinctive and personal quality quite unlike paper, perhaps due to the fact that we use cloth in such a personal way in our clothes and homes.

Each cloth fabric conjures up an image. Velvet becomes elegance, old lace evokes nostalgia, torn burlap or sackcloth is a sad story, flowered chintz

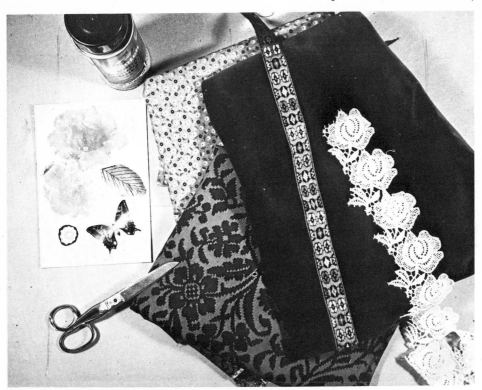

Illus. 60. Velvet, calico, flowered fabric, lace flowers and ribbon are some of the many fabrics that can be used in a collage.

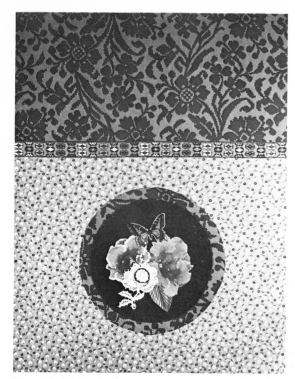

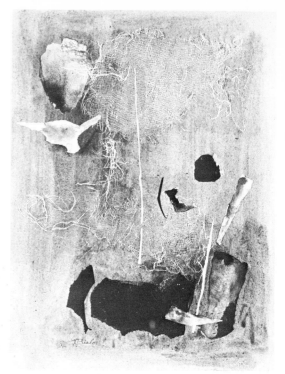

Illus. 61. A simple, but elegant, collage is created with the fabrics in Illus. 60. Cut-out paper flowers and a paper butterfly are added to the velvet circle for a change of texture.

Illus. 62. Gauze bandaging material gives an interesting texture to this collage of small pieces of hand-colored papers pasted on a wash background.

becomes a sunny morning—each fabric has its own character.

Every type of fabric can be used for collage, from old paint rags to a child's hair ribbon. Look in your closets, sewing drawers, and go to thrift shops for odds and ends of fabric. Make a collage entirely from scraps of cloth or cut-out elements from a patterned fabric and combine them with

paper. You will find that the addition of cloth elements gives another dimension to a paper collage. You can cut cloth, tear it, crumple it, paint it or drape it.

Because fabrics are not as stiff as paper, you will find it easier to paste them with spray-can glue rather than white glue. Masonite is probably the most satisfactory backing for fabric collages.

Assemblage

A collage made with three-dimensional objects is referred to as assemblage. The principle and approach are the same as in a paper or fabric collage. You are simply pasting *objects* instead of paper.

As with paper and cloth, you can use anything from feathers and beads to chess pieces. You can combine objects with paper and cloth or make an assemblage entirely from pasted objects.

When making an assemblage you will have to use a fairly heavy backing, such as Masonite or plywood. Undiluted white glue or epoxy glue (available at art supply shops) will paste almost

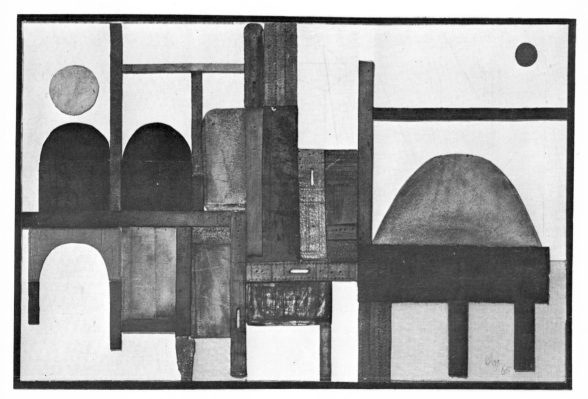

Illus. 63. "Architectural Series" by Olga Higgins. Pieces of leather and leather belts are pasted with undiluted white glue to a canvas-covered board in this structural collage. Lines on the leather are incised with a tracing wheel and fine pencil lines add interest to the background.

Illus. 65. "Shrine Series: Metamorphosis" by Ron Robertson. An extremely imaginative use of materials is evident in this assemblage, including an eggshell (filled with white glue for strength), acrylic-painted Bingo chips, cement, wire, cardboard and balsawood strips. The assemblage is sprayed with black silk-screen paint.

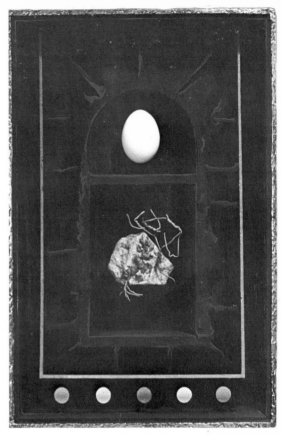

any object that you select, or you can use nails, wire, or staples to attach objects to the backing.

Now that you have progressed from your first paper collage to the assemblage stage, you will discover how much you have learned, not only about the possibilities of materials, but also the elements of composition and design. And look what fun you have had doing it!

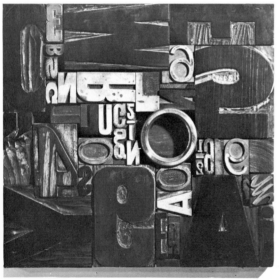

Illus. 64. "Communication Series #11" by Olga Higgins. This unusual assemblage is made with wood printer's type, gouged with carving tools. The inclusion of a metal machined ring provides extra interest.

More Ideas for Collage Elements

Paper

graph paper
confetti
colored writing papers
paper napkins
carbon paper
sandpaper
old checkbook stubs
old bills
old grocery lists
greeting cards
old blotters (ink-stained are fine)
old diaries
paper posters or notices
artificial flowers
calendars
labels from jars, cans, etc.
playing cards
old identification cards
paint charts
unwanted photographs
protective paper wrappings on towelling, tissues
paper plates
paper doilies
children's play money
Christmas seals, stickers, cards
cancelled postage stamps
charity stickers and seals
aluminium foil
cigarette, candy, and gum wrappers
picture postcards
shelving paper
circulars
window shades
paper drinking straws
potato bags
egg cartons
packaging papers on butter, bread, frozen foods

Fabric

carpet samples
shoelaces
old felt, knit, or velvet hats
rickrack
rope, string, twine
feathers
artificial furs
upholstery samples
cotton batting
ribbons
dressmaker materials
binding tapes
measuring tapes
braid
clothesline
discarded printed sheets, pillowcases, curtains
burlap
towelling
netting used for fruits
old leather handbags, gloves, belts
potholders
fabric eyeglass cases, key holders, billfolds
rug fringe
shade pulls
thread
yarn

And Things Like . . .

ice-cream sticks
tongue depressors
toothpicks
burned matches
cotton swabs
beads
lollipop sticks
Christmas glitter, tinsel, icicles
pencil shavings
combs
leaves
bottle tops
coat hangers
tacks, nails, and safety pins
old clock parts
staples
macaroni, spaghetti, etc.
popcorn
paper clips
bobby pins
pipe cleaners
shells
fish bones
egg shells
rubber bands
balloons
pebbles
dry cereals . . .

Index

assemblage, 45–46

backings, 6–7, 28
bags, 6
books, 9, 30–31
Braque, Georges, 4

canvas boards as backing, 6, 18, 45
cardboard, 20
 as a weight, 11, 42
 as backing, 6
catalogues, 31
chip board as backing, 28
construction paper, 8–10, 25

fabrics, 5, 24, 28, 29, 43–44

Gesso board, 7
gift paper, 7, 19, 22, 26, 28, 31
glues, 10–11

illustration board as backing, 6

magazines, 10, 16, 17, 20, 28, 29, 30, 34–35, 41

making colored paper, 37–41
maps, 8, 21, 31, 35
Masonite
 as a weight, 42
 as backing, 6–7, 20, 44, 45
matte boards as backing, 6

newspaper, 5, 7, 19, 22, 23, 25

paints, 13, 15, 16, 17, 18, 25, 38, 39, 42
paper, 6
 construction paper, 8–10, 25
 gift paper, 7, 19, 22, 26, 28, 31
 newspaper, 5, 7, 19, 22, 23, 25
 paper bags, 6
 rice paper, 6, 8, 17, 18, 22, 28, 37
 tissue paper, 6, 7, 9, 14–15, 16, 17, 18, 24, 29, 33, 37, 39

wallpaper, 7, 26, 27
waxed paper, 11
wrapping paper, 5, 7
pasting, 10, 11, 14, 15, 18, 44, 46
Picasso, Pablo, 4

rice paper, 6, 8, 17, 18, 22, 28, 37

shirt cardboard as backing, 6
straight pins, 10
stretched canvas as backing, 6

tearing paper, 8–9
texturing paper, 12, 13, 31, 32, 34, 38, 40–41
tissue paper, 6, 7, 9, 14–15, 16, 17, 18, 24, 29, 33, 37, 39

wallpaper, 7, 26, 27
waxed paper, 11
weighting the collage, 42
wrapping paper, 5, 7